Crystal Ball Photography

How to take breathtaking photos with a crystal ball

ABOUT THE AUTHOR

The travel photographer Stefan Lenz discovered his love for travelling in 2010. In the following eight years he visited a total of 51 countries on four continents. In 2016 he started travelling alone and focused more and more on his second passion which is photography. Meanwhile his photos regularly inspire several thousand followers on Instagram. In 2017, he launched his own blog about travel and photography. The most successful of his articles so far, made it into the top 3 of the German trending charts on the Steemit blogging platform. In 2018, Stefan decided to publish his knowledge and experience in the field of crystal ball photography in form of a guidebook. His goal is to provide his readers an overview as well as a starting assistance in this field of photography.

CONTENT

INTRODUCTION

You can see them more and more often on Insta-gram, Facebook, or other social networks: Fascinating glass ball photos. But the fascination that glass sphe-res exert on us humans is not new, it has existed for many centuries. In former times and partly still today they were and are used as traditional requisites, among other things for clairvoyance. They serve fortune tel-lers and clairvoyants as a transmission medium and should make hidden things visible. Glass spheres have also been used in parapsychology time and time again throughout history. The main aim was to research special forms of human perception. Today, the glass ball has lost much of its spiritual and mystical effect, but its beauty can still hardly be ignored.

When you read these lines here, you can certainly only confirm that, because otherwise you might not be in-terested in this topic. I also admired spectacular glass ball photos over and over again, before I finally deci-ded to add a glass ball to my photo equipment myself. It's basically not difficult to take great pictures with these fascinating objects, but there are still some things you should consider from the beginning. In this book I would like to tell you about my experien-ces and summarize all information which could be useful for you. I would like to offer you a starting support so that you can familiarize yourself with the creative possibilities and special features of the crystal ball right from the beginning. I am sure that you will have a lot of fun and joy when entering the world of glass ball photography!

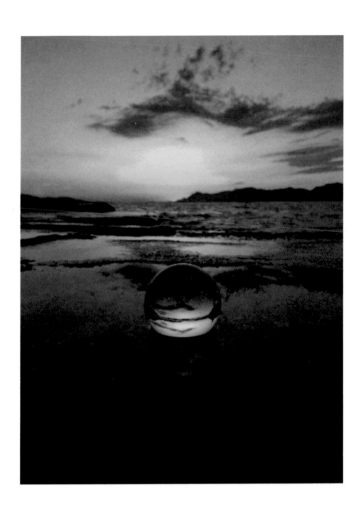

THE CHARACTERISTICS OF A CRYSTAL BALL

To be able to use a glass ball as effectively as possible for your photography, you should first of all consider what effects it has on your photos. Basically, a glass or crystal ball has three essential optical attributes:

First, it distorts the environment. At close range, it has the characteristics of a magnifying glass - it magnifies everything you hold close to it. A completely different effect becomes apparent when one observes a distant environment through it. Here it has a similar effect as so-called fisheye lenses. This means that straight lines that do not run through the center of the image are shown curved. One also speaks of a barrel-shaped distortion. This results in a very wide image angle. Thus, in a glass sphere, one sees more of one's surroundings than one perceives with the naked eye.

Nevertheless, there is a significant difference to a fisheye lens, which brings us to the second attribute. A glass ball turns the whole environment upside down by its curvature. Above and below are thus reversed. Outdoors the sky is located at the bottom of the sphere, while the ground is visible at the top. The third essential optical property may not catch your eye as quickly as the first two, but due to its smooth surface, a glass ball is always a mirror. Depending on which side the light comes from, you can see stronger or less strong reflections on its surface.

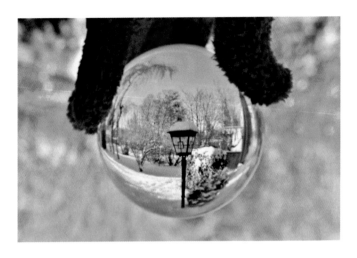

As soon as you own a crystal ball, your first step should be to familiarize yourself with its optical characteristics without using a camera and to consciously perceive them before you even think about areas of application. The best way to do this is to take a short walk in nature, look at your surroundings through the ball, but also at smaller details, and pay attention to how its effect changes depending on the distance to the object and the incidence of light. But there's one warning I'd like to give you first: be careful in direct sunlight! Because of the magnifying glass effect you could even accidentally inflame objects! I realized this effect myself only after several applications. I was on a trip to Macedonia when I held my glass ball with my hand in front of my camera on a sunny afternoon and suddenly felt a burning pain. As I was outdoors, I thought at first that I had been bitten by an insect. Only at the second time it finally became clear to me that it was the sunbeams bundled by the glass ball that caused this pain. Since then I avoid the use under intensive sunlight, which I also highly advise you!

Please take my warning seriously, because this characteristic of a crystal ball must not be underestimated!

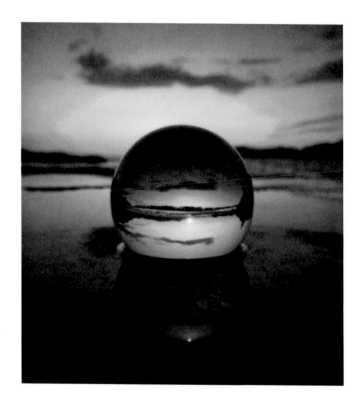

WHAT YOU SHOULD CONSIDER
BEFORE BUYING

If you decide to buy a glass ball, there are a few things you should consider before purchasing it. The first criterion is the quality of the glass. If you're looking at Amazon or other online retailers, you'll probably be pretty overwhelmed by the wide selection at first. You will see many different prices, ranging from about ten to fifty dollars. Besides the size, this is mainly due to the quality of the glass. The cheapest balls are more suitable for decorative purposes. Make sure in any case that the product description says something like "photography quality" or "suitable for photography". In order to take good pictures, your crystal ball should be clear and free of blemishes. The product photos won't help you at all, because all glass balls look perfect on the photos. It's better to stick to customer reviews. But don't worry, a good crystal ball doesn't have to be expensive. My glass ball only cost about 17 dollars. I am absolutely satisfied with it and I regularly achieve great results.

The second essential criterion when buying a glass ball is of course its size. Common sizes are between three and ten centimeters in diameter. I would definitely advise you to make sure that your glass ball is not too small. It should be at least seven to eight centimeters. Ten centimeters would be even better! However, another significant factor becomes important here: glass balls are naturally very heavy. A model with a diameter of ten centimeters can weigh about 1.4 kg. So even before you buy, consider whether you want to take your glass ball with you on your travels or just

use it at home. It becomes particularly critical if you are only travelling with hand luggage, because then the weight of the ball can make up 15-20% of the allowed total weight of your luggage. Also keep in mind that you will definitely feel the extra weight in your backpack if you plan to walk longer distances with it!

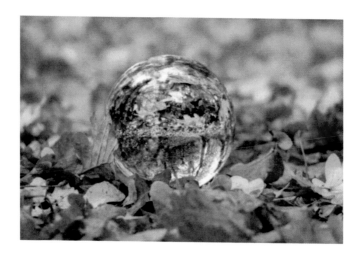

Personally, I chose a ball with a diameter of eight centimeters. It's big enough to achieve good results, and with just under 900 grams it's also reasonably acceptable in terms of weight. But I must honestly admit that I leave it at home from time to time when I am travelling with hand luggage only.

However, I can advise you not to buy a coloured glass ball. This looks very artificial on photos, while a clear ball always looks very natural and in ideal case it fits harmoniously into the image composition.

SELECTING THE CAMERA AND THE SETTINGS

You may be wondering if your camera and your lens are suitable for crystal ball photography at all. Fortunately, there are not too many criteria that your equipment has to meet in order to produce good results. Basically, even with a smartphone, you can get some useful shots done. It doesn't have to be the most expensive DSLR or mirrorless camera.

Probably the most popular effect photographers want to achieve with glass balls is clearly the one where the ball itself is sharply imaged while the background is blurred. How do you create this blurred background, also known as "bokeh"? Actually, there are only three factors that influence the bokeh: The first one is the size of your image sensor. This means that the larger the sensor is, the better you can isolate your object, which in this case is the glass ball. DSLR or mirrorless cameras have a full-frame sensor or a sensor in APSC format. With these two sensor sizes you definitely have the best preconditions for achieving a nice bokeh.

The second parameter is the maximum aperture of your lens. For example, all values up to f/2.8 would be very good, f/5.6 is not very useful in many situations and with high numbers like f/16 you won't get a bokeh at all. You notice that the smaller the number behind the "f", the more light your lens lets in and the better you can isolate your object from the background.

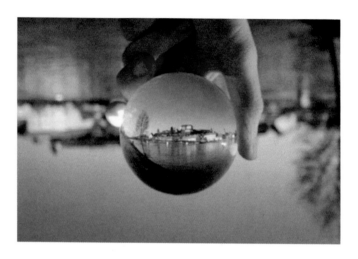

But there is a third factor that can give you a beautiful, blurry background. This factor is particularly important for smaller image sensors, such as those found in bridge or compact cameras, because you can't simply change the lens on these models. It's the zoom range. Many bridge cameras are also called super zoom cameras. I also have a bridge camera and my zoom reaches up to a focal length of 200 millimeters. But some models even offer 600 millimeters or more. If you have such a camera, don't go close to the glass ball with a wide angle on your lens, but zoom out fully and then move back until the ball appears as large or small on the viewfinder or display as you want it to appear. You'll see that it's also possible to create a blurred background this way.

What you need to keep in mind is that the distance from your object to the background must not be too small.

For example, if you hold your glass ball close to a wall, you won't get a decent bokeh even with the largest image sensor, a lens with a very open aperature, and the zoom fully extended.

Another point that you should not ignore is the close-up limit of your lens. This is especially important for photos in which you want to capture the glass ball as large as possible. Your lens must be able to focus on the object even at a small distance. Lenses with macro characteristics are best suited for this.

When it comes to camera settings, there is actually hardly anything that applies specifically to glass balls. Of course, it is important that the focus point is exactly on the ball. If your camera has a bad, error-prone autofocus, you should rather focus manually. In my opinion, there's nothing wrong with working in automatic mode if it delivers good results. If you make manual adjustments and take hand-held photos, I would recommend you not to go below 1/250 second for the exposure time. With a tripod, your possibilities in terms of exposure time are of course much wider. You should set the aperture to the smallest available number if you want to achieve a blurry background, or to a high a value if both the glass sphere and the background should be sharp. However, if you are very close to your object, the lowest f-stop may prevent the entire sphere from being sharply displayed. In this case, increase the aperture value slightly. In any case, I would leave the ISO value in automatic mode and only adjust it if you notice that the image noise is too strong. The lower the ISO value, the less noise your image will have. In general, you should take enough time to experiment with the settings.

ENVIRONMENTS THAT ARE MOST SUITABLE

One nice thing about taking pictures with a glass ball is that you don't need any special places to get beautiful results. As an example, look at the photo below, which was simply taken in the middle of an ordinary street. This street could be almost anywhere and the lighting conditions aren't spectacular either. Still, the shot looks pretty interesting, don't you think?

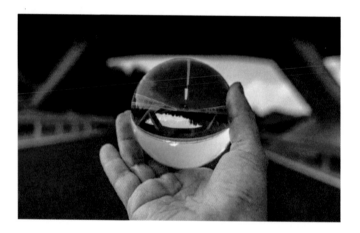

Basically, you can enhance any scene with a glass ball, such as beautiful sunsets by the sea. A glass ball is particularly suitable for spacious landscapes due to its wide-angle effect, but you will also find great applications in cities again and again. Lights from street lamps or vehicles can bring beautiful bokeh effects to your photos. This is especially true for night shots. However, it could be more difficult with architectural shots, especially since straight lines are displayed

strongly curved. The building you want to capture should therefore be far enough away from the glass ball. The big advantage is that you can display huge structures inside the sphere completely, for which even your wide-angle lens is not sufficient. However, glass balls are completely unsuitable for portraits. Nevertheless, photography is still an art form and maybe you will find a way to take great portraits with the help of glass balls. Fortunately, there are no limits to your creativity. Over time you will probably notice, however, that especially with glass ball photos less often is more. Since the sphere is your object, you don't necessarily need an additional object. Of course, it's especially great to have a glass ball with you during a trip so that you can use it in many different places and with different lighting conditions. If you enjoy photography, you will certainly enjoy experimenting with glass ball photos as well.

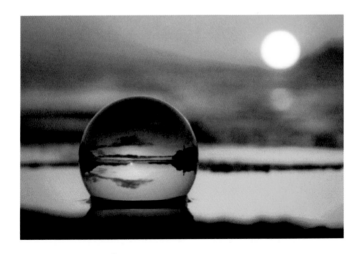

CREATIVE IDEAS AND POSSIBILITIES

As already mentioned, there are no limits to your creativity, but if you need some inspiration, I want to show you a few ways how you can present your glass ball particularly effectively.

A very popular option is to take the glass ball in one hand and photograph it with the camera in the other hand. Of course, it becomes even easier if you are accompanied by a person who holds the ball for you, so that you can use both hands to take pictures. Basically it also works very well if you are alone.

It is also very popular to rotate the photo during post-processing so that the top and bottom of the ball are no longer swapped. Of course, everything else around the ball is displayed upside down then. If your glass ball is lying on the floor, it will look as if it's sticking to the ceiling. This effect creates a somewhat confusing and therefore pretty interesting impression.

While most people hate them, photographers love them: puddles! Even without further equipment, you can achieve phenomenal pictures because of the mirror-effect. But don't be afraid to put your glass ball into a puddle. This will give your shots a very special wow-effect, even if you will often be faced with surprised looking pedestrians in city centres. If you often take pictures in cities, you may already be used to that.

It's raining cats and dogs outside? That's no reason to let your glass ball get dusty in the cupboard. With a plastic box, a perforated metal plate, which you can

get cheaply at a hardware store, and some coloured plastic foil, you could build a small set at home. Put the plate onto the box and place the ball in the middle of the plate. Under the box you place an external flash, over which you stick the coloured plastic foil. Behind the box you place a reflector and you're ready to go. Of course you can change and adapt this set to your own taste.

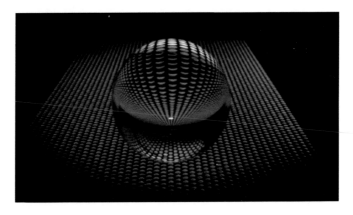

If you were accompanied by a second person, you could ask him/her to throw the ball up a bit with one hand and then catch it again. With your camera, you try to press the shutter exactly when the glass ball "floats in the air". Make sure that you set the exposure time to be as short as possible, otherwise the ball will appear blurry - despite precise focus. Of course, you should also make sure that your glass ball lands as softly as possible if your companion is not able to catch it once it has been thrown up. If you catch the right moment, the photo will look as if the ball is actually floating in the air. Let your companion throw the ball up a few times in a row and catch it. Later you can pick out the best shots.

These were just a few examples of many possibilities. I'm sure that the more you spend time with your glass ball, the more photographic ideas you will have yourself.

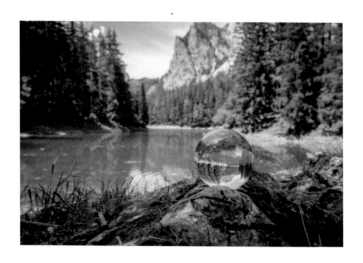

CLEANING, MAINTENANCE, TRANSPORT AND STORAGE

In order to be able to work with your glass ball for as long as possible, you should of course pay attention to certain things regarding the correct handling of it. You will certainly know for yourself that you should treat it like a raw egg. If it falls out of your hand only once and lands on a hard floor, it will at least be severely damaged, but very likely even completely unusable after that. Especially with photos for which you hold the ball in your hand, you should make sure that you have it tightly gripped. If your hands are sweaty or wet, be sure to dry them first. If you use gloves, you will avoid fingerprints, but the glass ball could slip out of your hand even more easily. You should also pay special attention if you place the ball on a hard surface. The last few millimetres before it touches the ground you should move it extremely slowly to keep it undamaged.

When it comes to cleaning, a microfiber cloth is the right choice to remove fingerprints from the ball. If for any reason it is more dirty, you can also wash it with lukewarm water and dry it with a tea towel. However, it would be optimal if the ball really only came into contact with microfiber cloths. Some photographers also recommend using a glass cleaner, which shouldn't be a problem at all. Under no circumstances should you brush the surface, as this could cause scratches. If your glass ball comes into contact with salt water, you should rinse it immediately afterwards with clean water, since the salt attacks the glass and the ball could become cloudy.

Of course, it is very important that you transport your glass ball securely to protect it from shocks and scratches. My glass ball was sent to me in a quite attractive box, which turned out to be absolutely unusable, as the ball was not firmly enclosed in it, so that it rolled around in the box with the slightest movement. In addition, you couldn't close the lid tightly without using tools. I hope, of course, that you will be more lucky and get a package that is also suitable for transport. In case of doubt you could ask the manufacturer. However, a transport box is not absolutely necessary. I have found a quite simple, but safe replacement solution: First I wrap my glass ball in a microfiber cloth and then again in a towel. So I simply put it into my backpack or suitcase. On the one hand the ball is optimally protected from scratches by wrapping it in a microfibre cloth, on the other hand it is also softly padded by the towel and therefore resists slight shocks.

When it comes to storage, there is hardly anything to consider. When I don't need it, my ball lies in the cupboard at home, wrapped in a microfibre cloth and a towel. Just make sure that you store it in a dry place and that you have it well fixed. Of course, it is also important that it is not exposed to direct sunlight because of the magnifying glass effect already mentioned. After all, you don't want to inflame your home.

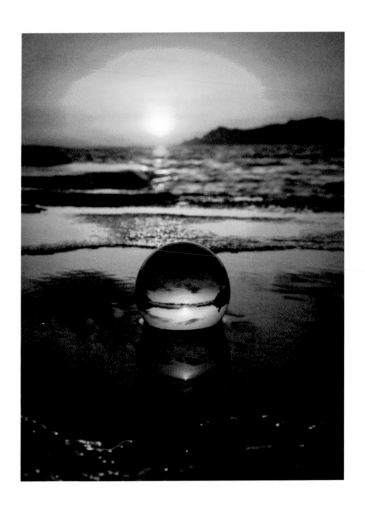

THE POST-PROCESSING OF YOUR PHOTOS

If you really want to get the maximum quality and beauty out of your glass ball photos, you won't be able to avoid post-processing. There are really very few photos that have nothing to optimize. In most cases, however, it's possible to get more out of them in terms of correct exposure and color temperature, as well as contrast and sharpness. But of course you can also get creative in the post-processing and distort your photos in such a way that they are hardly recognizable.

For the optimization as well as for the modification of the photos I would recommend you the image editing programs from Adobe. Especially with Photoshop you have a very powerful tool. There's almost nothing you can't do with it. If it's just about optimizing settings, then Adobe Lightroom is the much better choice. If you don't have any experience with image editing programs yet, I would recommend you to start with Lightroom. The two programs are only available as annual subscriptions, for which you currently pay almost 12 dollars per month. However, you will always have the latest version by regular updates. If you want to get into image editing extensively, it is definitely a worthwhile investment. Considering the high quality of the software, the price is also acceptable, especially since there are hardly any competing products on a similar level. I could also recommend the software "Luminar" from Skylum. Nevertheless, in my opinion Adobe's programs are much better.

If you don't want to get seriously into image editing, you can of course work with filters to give your glass ball photo a different effect. But be careful not to exaggerate. When editing images, whether with filters or manually, sometimes less is more! An overworked photo often looks much worse than the original.

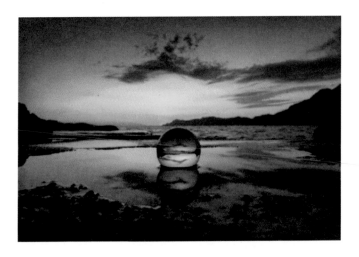

What exactly you could change or optimize in your pictures depends of course on the specific photo. It is therefore difficult to give generally valid advice about that.

A popular effect - as already mentioned - is to rotate the photo by 180 degrees. You could also darken the background or lighten the glass ball a bit to highlight it even more.

If your camera can save photos in RAW format, you should definitely activate this for post-processing purposes. RAW files store more detailed image information, which gives you more possibilities for post-processing. Some cameras also offer the option to save photos in RAW and JPEG format at the same time, which I think is an optimal solution when you're traveling. So you can later delete those RAW files that you don't post-edit, especially as they take up a lot of storage space. The smaller JPEG files, on the other hand, you can keep as a souvenir.

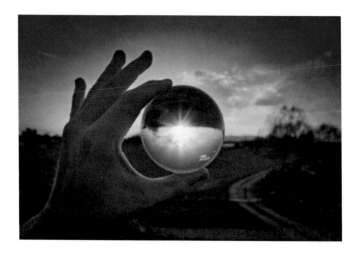

TIPS AND TRICKS

I would now like to give you a few tips that will certainly help you when using your glass ball. Some of them I have learned from my own experience, others have been recommended to me.

The first tip concerns something you should - if possible - avoid. Most glass balls come with a glass base, so you can place them anywhere safely without them rolling away. If you want to use the ball as a decoration in your home, you can use this base of course, but please do not use it for photography! It will look like a foreign object on all of your photos. Just leave it at home so you don't get tempted to ruin great photos with it.

Maybe you are wondering how else you can fix your glass ball on a smooth surface. There is a very simple but effective solution for this: Just sprinkle some salt on the smooth surface and then place the ball on it. A small pinch is enough and your glass ball can no longer roll away. The tiny, transparent grains of salt can hardly be seen on the photos. On medium- and long-distance flights you often get very small salt packets served with the food. For example, you could take these with you and use them for your glass ball photography.

Another way to fix the ball is to place a small, ideally transparent sealing ring under the ball. I've seen some photographers using such a ring, but there is a big disadvantage: If you look closely, you'll probably notice it on the pictures.

Another nice stylistic technique is to place the ball so that the lower half is covered by something in the foreground. This can add depth to your shots and make them look particularly interesting and unique.

When looking for a suitable motif, it might be helpful to hold the ball in front of your field of vision with one hand and look around. If you walk around with the glass ball in front of your face, you might get a few confused glances, but you'll know immediately where you can use it most effectively.

Note that inside a glass ball not only everything is upside down, but also left and right are swapped. You can use this for your image composition especially if you don't place the ball in the middle of the photo. It can give your shot a very special touch if you have a slightly blurred but still recognizable part of the background on one side and the glass ball on the other.

If you take a picture of your glass ball in your hand, then take a look at your hand before you unpack the ball. Especially as a photographer, you are often fully committed to the task and can get dirty hands or fingernails relatively quickly. When looking through the viewfinder you could be focused only on the glass ball, so that you would not notice dirty spots on your hands at all. However, when you post-process them on the big screen, they'll catch your eye and they will be hard to retouch. So take a few seconds to make sure your hands are clean.

Remember, if you go very close to the glass ball with your camera, the ball will mirror you and your camera. It is therefore advisable to zoom in rather than to get too close to the ball.

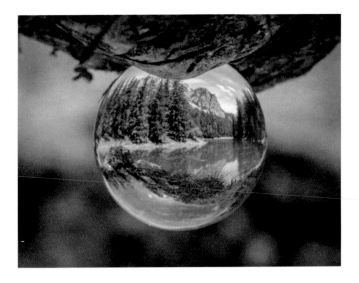

CLOSING WORDS

I hope you enjoyed this introduction to the world of glass ball photography and you have learned something that you will apply in practice. Don't worry if you don't achieve the desired results right away. As with so much, the same applies in this area: Practice makes perfect! I have tried to summarize all worth knowing and useful information about the topic "glass ball photography" as compactly as possible for you. If you missed something essential, please let me know! I am very grateful for any constructive criticism. If you enjoyed my book, then of course I would be very happy if you would leave me a positive review on Amazon!

If you want to know more about my photography and my travels or would like to contact me, then have a look at my website! There you will also find links to my social media channels and my other books.

www.stefanlenz-photography.com

I wish you much joy and success with your glass ball photography from the bottom of my heart!

Stefan Lenz

Twilight Photography

Golden Hour & Blue Hour

The time around sunrise, sunset, dawn and dusk is particularly suitable for taking impressive photos and of course also wonderful crystal ball pictures. If you want to know how you can make the best use of these periods for your photography, then my book on this subject might be interesting for you. You can find it under the category "books" on my website!

Imprint

Crystal Ball Photography

How to take breathtaking photos with crystal balls

Copyright © 2018 Stefan Lenz

1st edition

ISBN: 9781723755965

Stefan Lenz, Donnersdorf 22, AT-8484 Unterpurkla

Disclaimer

The content of this book has been checked and compiled with great care. For the completeness, correctness and topicality of the contents however no guarantee or guarantee can be taken over. The content of this book represents the personal experience and opinion of the author and is intended solely for entertainment purposes. Therefore, no legal responsibility or guarantee can be assumed for the success of the tips and advice mentioned. The author assumes no responsibility for the non-achievement of the goals described in the book. This book contains links to other websites. The author has no influence on the content of these websites. Therefore no guarantee can be assumed for this content. The respective provider or operator of the pages is responsible for the contents of the linked pages. Illegal contents could not be determined at the time of linking.

50518693R00019

Made in the USA
Lexington, KY
28 August 2019